MEDIEVAL MOTIFS

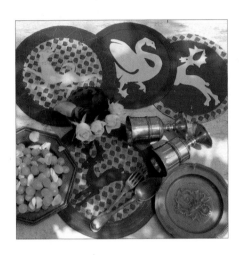

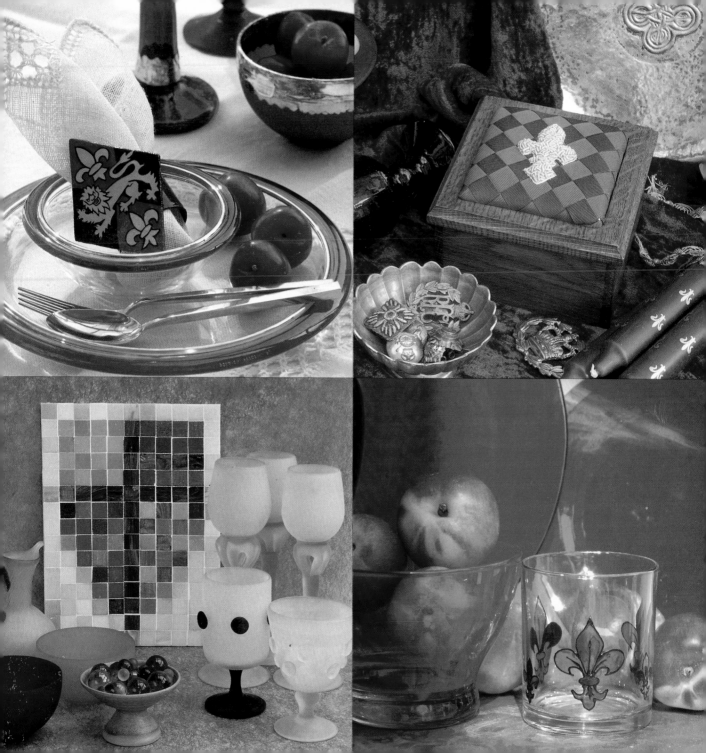

MEDIEVAL MOTIFS

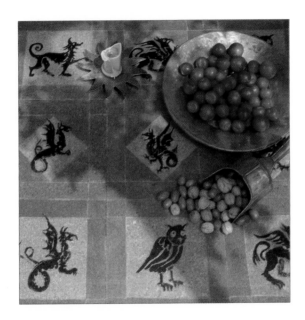

JOANNE RIPPIN

PHOTOGRAPHS BY MICHELLE GARRETT

LORENZ BOOKS

NEW YORK • LONDON • SYDNEY • BATH

This edition published in the UK in 1997 by Lorenz Books

This edition published in the USA by Lorenz Books
27 West 20th Street, New York 10011

LORENZ BOOKS are available for bulk purchase for sales promotion and
for premium use. For details write or call the manager of special sales:
Lorenz Books, 27 West 20th Street, New York, NY (212) 807-6739

Lorenz Books is an imprint of
Anness Publishing Limited

ISBN 1 85967 346 5

Publisher: Joanna Lorenz
Introduction: Beverley Jollands
Designer: Lilian Lindblom
Photographer: Michelle Garrett
Step photographer: Janine Hosegood
Illustrator: Lucinda Ganderton

Printed in China

1 3 5 7 9 10 8 6 4 2

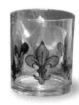

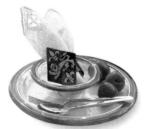

Contents

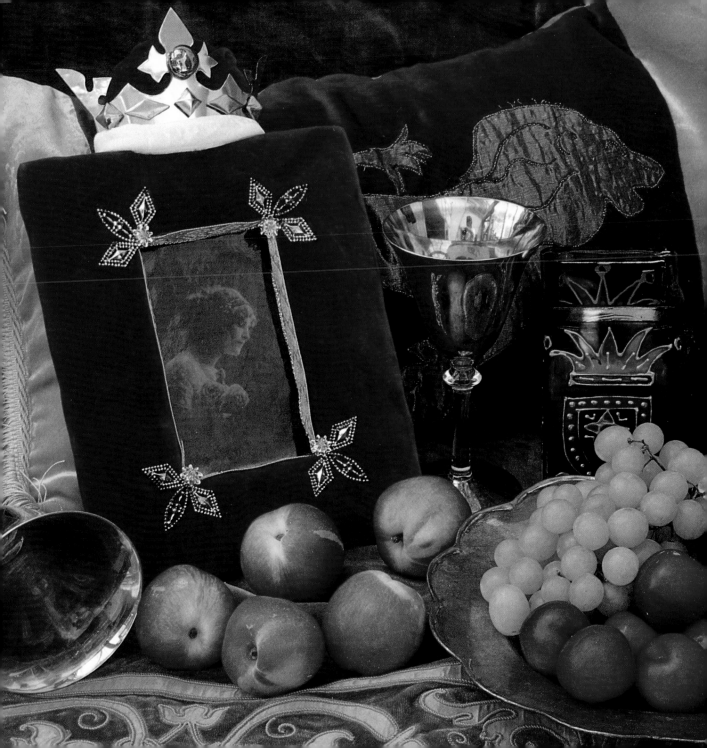

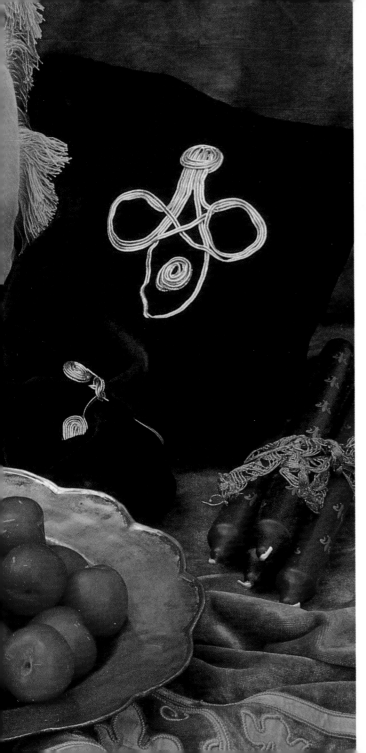

INTRODUCTION

Whiten medieval fighting knights were encased from head to toe in metal, it was hard to tell them apart. They took to painting their shields to advertise their presence. The earliest designs were simple abstract patterns such as bars or chevrons in just a couple of colors, perhaps echoing the reinforcing panels of the shield. The Norman soldiers depicted on the Bayeux Tapestry bore shields with devices like this. They were used not only on the shield but elsewhere on the knight's armor, his horse and his banner. Modern jockeys' colors fill the same function, as a logo on horseback.

Heralds officiated at tournaments, announcing the champions, enforcing the rules, and delivering challenges. They were also busy on the real battlefield, identifying the victors and the vanquished, so they had to be able to recognize the various devices. They became experts: they could advise the new knight on how to avoid duplicating someone else's shield, and ultimately they were given the power to grant the arms themselves. From this grew the whole paraphernalia of heraldry which began to extend from tournaments to the wider medieval world.

In their diplomatic role, heralds had to cross enemy lines; they were unarmed and wore distinctive tabards decorated with the arms of their sovereign. Tabards and armorial banners were, and still are, thickly appliquéd and embroidered. Lions, dragons, harps, fleurs-de-lis and the other fabulous symbols of heraldry are worked in gold and silver thread on brilliantly colored grounds of silk damask, edged with gold cord and so thick and textured that they are virtually three-dimensional.

By the mid-13th century a shield was no longer a simple badge of recognition; it had become an important symbol of the nobility of a family. It also acted as a record of family alliances when it was quartered to commemorate dynastic marriages. Although the patterns became more involved, the colors and shapes remained bright and bold. The heralds enforced rules about their design, and an important one was that metal could not be used on metal, nor color on color. This explains the large amounts of gold or silver

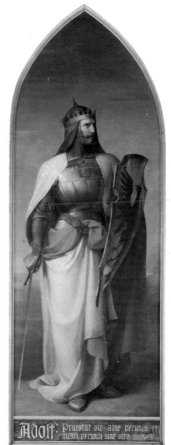

that are used on armorial shields.

Heraldry became increasingly important in the interior decoration of houses that had the right to display it. Shields and coats of arms made excellent decorative symbols on walls, hangings, tapestries, silver and stained glass. The broadly drawn symbols and bold colors lent themselves to being used as patterns and, of course, proclaimed the grandeur of the family.

Because they were seen as emblems of the family's pride and honor, heraldic decorations tended to be used on treasured and precious possessions rather than everyday objects, so they have a traditional affinity with rich and luxurious materials: silks, velvets, silver and gold, fine porcelain.

Armorial tableware became very popular in the 18th century, when decorated porcelain was exported in vast quantities from China to Europe. The Cantonese painters copied the

Above: A striking portrait of the 13th-century King Adolf von Nassau in full battle dress and bearing a typical heraldic device on his shield.

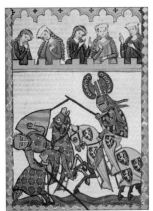

armorial bearings that were sent out when a dinner service was commissioned, often in the form of a piece of family silver, so that the painted arms on Chinese export porcelain frequently resemble engravings. The fashion for drinking from glass instead of metal swept through Europe in the 16th century, and fine Venetian glass for the table was engraved with family crests just as silver and pewter vessels had been before.

Arms were used to personalize books, both stamped into bindings and as printed bookplates, and fine examples of both forms are now sought by modern book collectors. In the 19th century it became the vogue to emboss the family arms on one's stationery, while highly valued seal rings and fobs, set with precious stones engraved with a shield or crest, had long been used to leave a personal mark on correspondence.

Beyond the confines of the family, coats of arms were granted to cities and institutions. Independent cities demonstrated their autonomy by erecting their arms, carved in stone, over their gates. But conquering powers did the same, and the winged lion of Venice, for instance, can be seen carved in stone wherever the republic extended its rule.

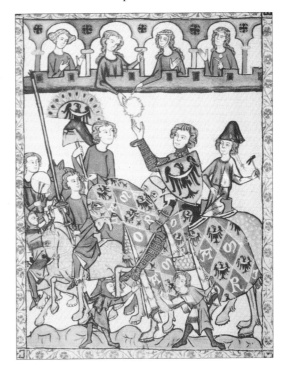

Above: A triumphant knight receives his prize from a lady of the court while heralds perform their administrative duties all around him.

Top: A 14th-century depiction of two jousting knights covered in the personal heraldic devices by which they would be recognized on the field.

Alongside the armorial shield, the simpler device of the badge was used as part of the livery of a noblman's retainers. It came to prominence during the rise of the factions who fought the Wars of the Roses (the red and white roses themselves were two such emblems). One of Richard II's badges was the white hart, and in the Wilton Diptych not only is he shown wearing a robe embroidered all over with harts, but the angels surrounding the Virgin also wear badges with the same emblem, as if they are part of the king's retinue. The fleur-de-lis, chief symbol of the kings of France, was a perfect motif for a repeating pattern and was used as an all-over design on banners, tents and garments.

The shield itself is only the beginning, though the central part, of the heraldic symbol. The whole coat of arms incorporates supporters – lions are the most common, but they may be other animals or people and are usually adapted from the bearer's badge. At the top is the crest; originally the knight's helmet with its distinctive plumes, perhaps a crown. At the

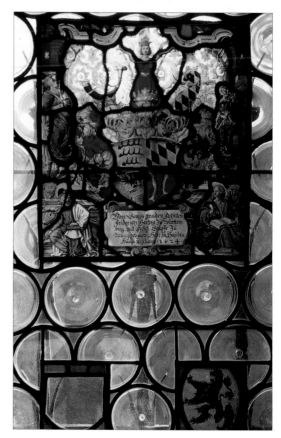

Top: A sculpture of Charles IV of Luxemburg, together with a simple depiction of the insignia which would have made up part of his livery.

Above: A highly decorative coat of arms, in rich colors, forms the panel of a window dated 1624.

bottom is the motto, often in Latin, often a wordplay based on the family name.

If you are the scion of a proud and ancient family, you can use your intricate coat of arms, with its historic quarterings and arcane symbols in sable, azure, or red, to decorate whatever you like. If not, why not borrow some of those striking patterns and colors and invent your own armorial bearings, or make some up for a friend? The age of chivalry may be dead, but heraldry is still very much with us, not just for those eager to display their noble birth, but as a striking motif on everything from stationery to handbags, school uniforms to bottles of wine.

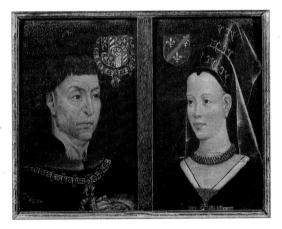

Above: A painting of Charles the Bold, duke of Burgundy, and his wife, with their respective arms.

Above: The inscription and flamboyant coats of arms of the Schmidburg and Pistoris families, linked by garlands of plants.

FLEUR-DE-LIS VELVET SHOE BAG

Rich purple velvet and opulent gold braid suit the regal motif on this luxurious bag for your best party shoes. The appliquéd braid technique could easily be adapted to other items such as cushions and throws.

YOU WILL NEED

MATERIALS
*cotton velvet fabric,
 21 x 15 inches
gold embroidery floss
gold braid
black satin ribbon, 1½ inches
 wide
short length of ½-inch-wide
 elastic*

EQUIPMENT
*scissors
pins
tracing paper
pencil
paper for template
sewing needle
sewing machine
safety pin*

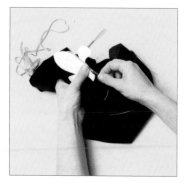

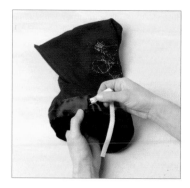

1 Cut the velvet in half across its width and mark the center of one piece with a pin. Trace and cut out the motif from the back of the book and pin to the center of the velvet toward the lower edge. Using gold embroidery floss, sew on the gold braid, pinning it around the template as you stitch. Work in a continuous pattern, then add the swirls.

2 Machine-stitch the sides and hem, leaving a ½-inch seam allowance. Neaten the raw edges. Fold down the top edge, leaving a generous cuff. Cover the raw edge with satin ribbon, stitching along both edges to form a casing. Fold the ends of the ribbon under and butt them together. Thread a short piece of elastic through the casing and stitch the ends together.

3 Complete the bag by making a tie with another length of braid, coiling and stitching the ends. Attach to one side seam and tie around the neck of the bag.

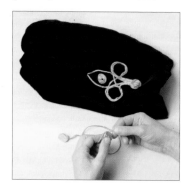

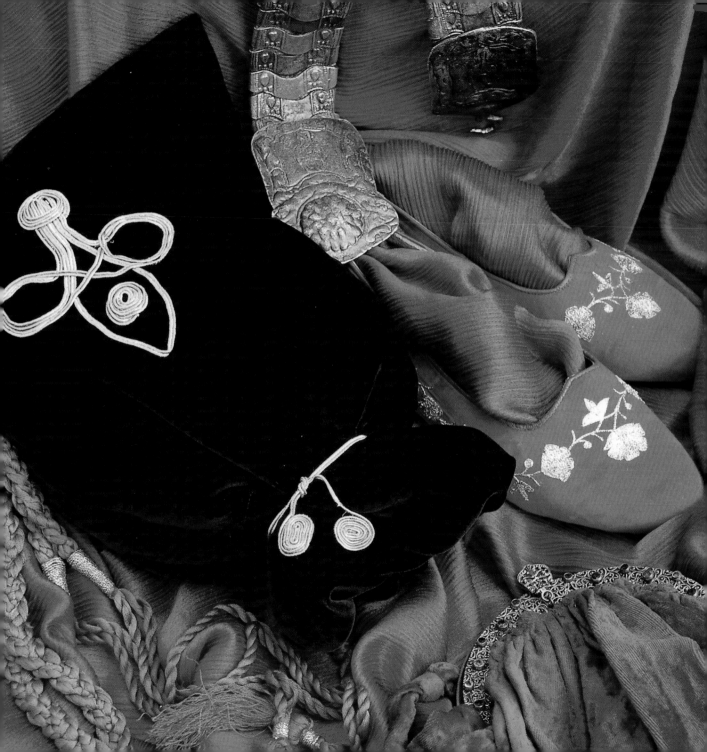

ENGLISH LION CUSHION

Choose harmonious velvets in glowing "antique" colors to make luxurious cushions, which will add a touch of elegance to any room. The glittering metallic organza used to make the lion gives him a subtle gilded look.

YOU WILL NEED

MATERIALS
cotton velvet fabric: 12½ x 17 inches in deep red, 12½ x 34½ inches in orange
metallic organza, 12½ x 17 inches
metallic machine embroidery floss
matching sewing thread
pillow insert, 11 x 21½ inches
28 inches fringing

EQUIPMENT
tissue paper
pencil
basting thread
sewing needle
embroidery hoop
sewing machine with darning foot
scissors
pins

1 Scale up the template at the back of the book and trace onto tissue paper. Baste the tissue to the wrong side of the red velvet and the organza to the right side. Stretch in an embroidery hoop. Using the free embroidery mode, machine-stitch the design. Remove the tissue and basting threads. On the right side, trim away the organza from the outer edge of the motif. Put the piece back in the hoop right side up and sew a narrow zigzag stitch to cover the edges.

2 Cut two 12½ x 4¼-inch strips of orange velvet. With the right sides together, stitch these to either end of the panel. Cut two pieces of orange velvet, 12½ x 19 inches and 12½ x 7 inches for the back. Stitch a narrow double hem on the overlapping edges. Pin the fringing along both short ends of the embroidered panel. With the right sides together, pin the backing pieces to the front, overlapping the hemmed edges. Stitch, turn to the right side and insert the pillow insert.

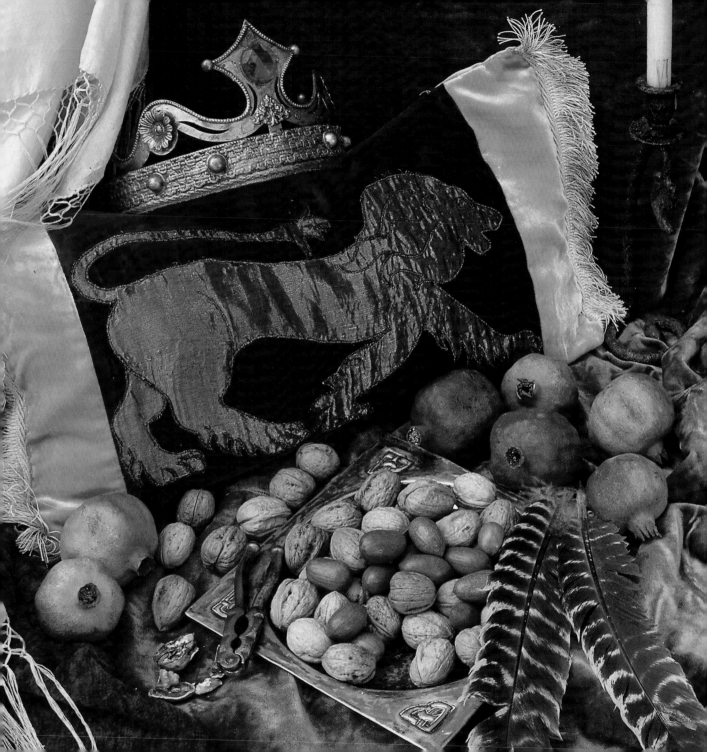

FLEUR-DE-LIS BOX

This design makes the most of the bold colors and geometric patterns of heraldry. The crisp textures of the materials used are as eye-catching as the brilliant colors.

YOU WILL NEED

MATERIALS
fusible bonding web, 5 square inches
calico, 10 square inches
½-inch-wide textured ribbon:
 1 yard each of red and green
bright yellow felt
gold bullion, size 2: 15 inches each of rough and smooth
sewing thread: yellow and black
gold metallic embroidery floss
dark oak trinket box with lid for 4-inch padded insert

EQUIPMENT
iron
cork board
scissors
pins
sewing machine
embroidery hoop
sewing needle
large-eyed needle

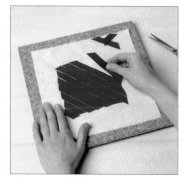

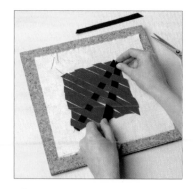

1 Iron the bonding web in the center of the calico square. Lay the square on a cork board. Cut the red ribbon into strips and lay them diagonally across the bonding web and pin.

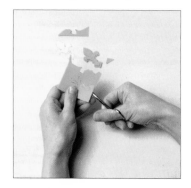

2 Weave strips of green ribbon diagonally through the red strips in the opposite direction. Press to bond and remove the pins. Stitch around the edge to secure the strips.

3 Using the template from the back of the book, cut three graduated fleur-de-lis shapes out of the felt. Place the smallest in the middle of the square and lay the larger pieces on top. Pin.

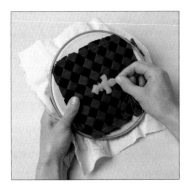

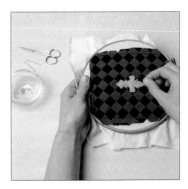

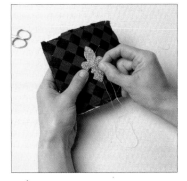

4 Stretch the panel in an embroidery hoop. Stitch around the felt with small hemming stitches, bringing the needle up close to the felt and down through the edge.

5 Cut the bullion into small pieces. Thread alternate types onto the needle one at a time and stitch down like beads in a random pattern all over the felt.

6 Couch two strands of gold metallic thread around the edge of the fleur-de-lis, leaving 2-inch ends on the right side. Couch the strands separately at the corners.

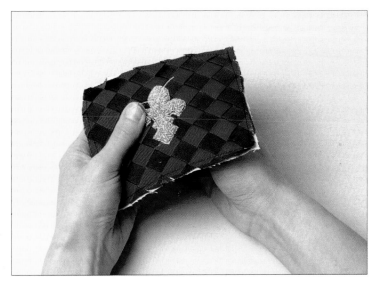

7 Use a large-eyed needle to pull the ends through to the reverse side. Trim and stitch securely. Trim the edge of the panel close to the machine stitching.

8 Lay the panel on top of the padded box insert. Ensure that it is straight and pin on all sides. Stitch two opposite edges together using a double thread and pull up tightly. Repeat with the two remaining edges. Insert in the lid and screw in position.

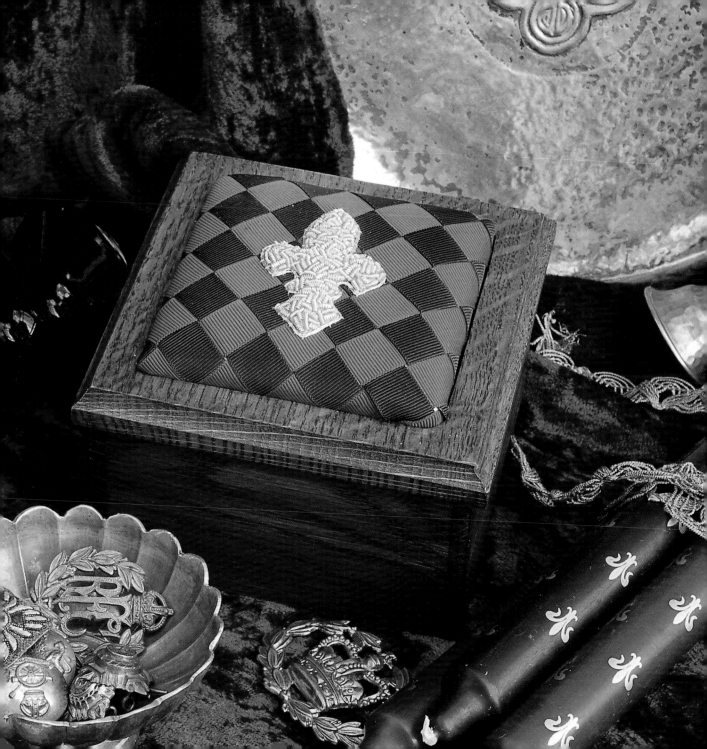

HERALDIC CANDLE JAR

A straight-sided jar is a good shape to choose if you haven't tried painting on glass before, as the flow of the paint is easiest to control on a flat, level surface. As the candle burns down inside the jar, the jeweled colors of the heraldic device will really start to glow.

YOU WILL NEED

MATERIALS
glass jar containing a candle
gold glass-painting outliner
solvent-based glass paints: red,
 green, purple

EQUIPMENT
rubbing alcohol
paper towels
paintbrushes
turpentine

1 Wipe the jar with alcohol to remove any remaining traces of grease.

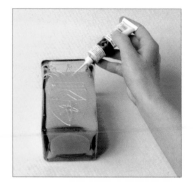

2 Lay the jar down on its side. After a few practice runs on an old jelly jar, draw the design carefully with the gold outliner. Allow this to harden for at least 12 hours before starting to color your design.

3 When painting the background, apply the glass paint thickly to avoid streaky brush strokes. Be careful not to allow the paint to run down the sides of the jar; if it does, wipe off immediately with paper towels and turpentine. Complete the design and let dry for at least 12 hours before starting on the next side.

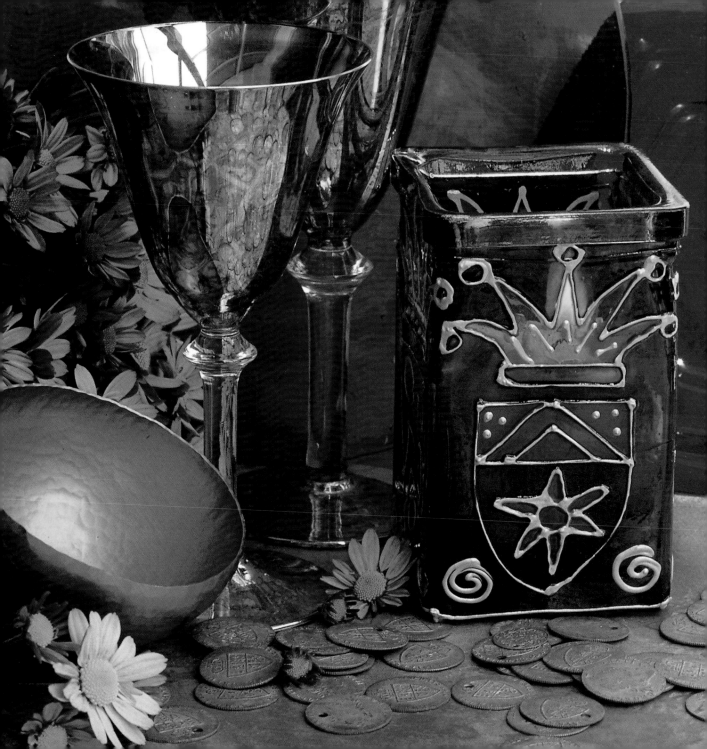

FLEUR-DE-LIS TERRA-COTTA TILES

This design is based on part of the medieval flooring in Winchester Cathedral. The original tiles were made by inlaying a light-colored clay into terra-cotta before they were fired, but this modern version can be quickly stenciled using acrylic paint.

YOU WILL NEED

MATERIALS
unglazed 5 inch-square terra-cotta tiles
cream acrylic paint
clear matte acrylic spray varnish

EQUIPMENT
tracing paper
pencil
stencil cardboard
craft knife
cutting mat
spray adhesive
stencil brush

1 Scale up the template at the back of the book so that the design fits onto a tile leaving a narrow border. Transfer it to stencil cardboard and cut out with a craft knife.

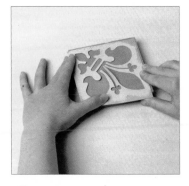

2 Wash the tiles with detergent to remove grease and loose dust. Let dry thoroughly. Spray the back of the stencil lightly with adhesive and smooth in place on the first tile.

3 Paint in the design with small circular movements of the brush. Be careful not to overload the brush with paint.

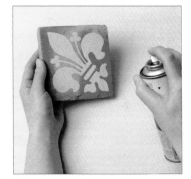

4 Peel off the stencil and let the paint dry completely. Finally seal with several coats of clear matte acrylic varnish.

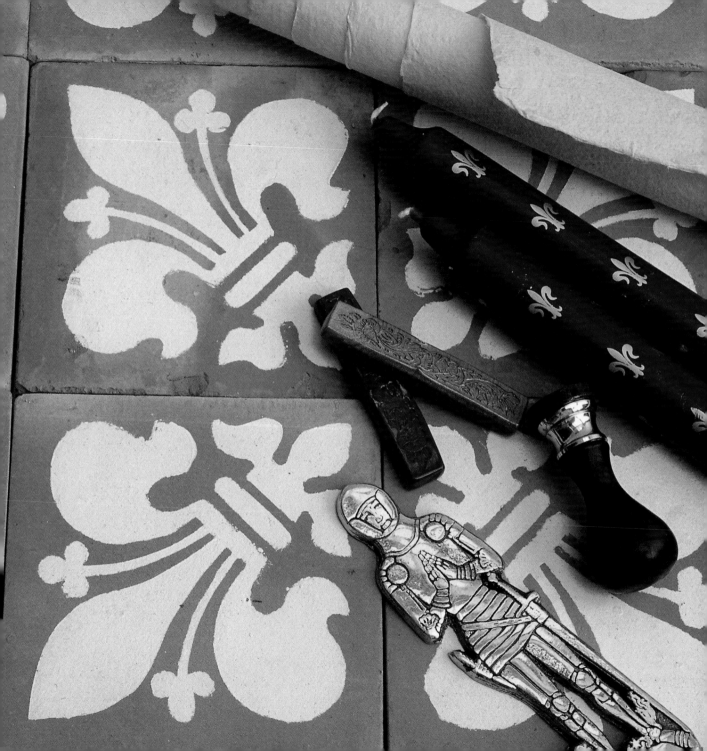

UNICORN PENNANT

The unicorn is the most romantic and graceful of all the fabulous beasts of heraldry. His elusive nature is reflected in the cool colors used in this pennant.

YOU WILL NEED

MATERIALS
four complementary cotton fabrics, each 6 x 8½ inches
cotton fabric for backing, 11 x 16 inches
matching sewing thread
fusible bonding web
unbleached calico, 10 square inches
gold machine embroidery floss
1½ yards wire-edged fleur-de-lis ribbon
14-inch wooden pole with sanded ends
dark blue craft paint

EQUIPMENT
scissors
sewing machine
iron
thin cardboard for template
pencil
sewing needle
pins
basting thread
paintbrush

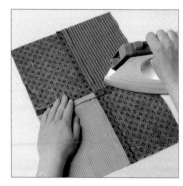

1 Attach the fabric rectangles in pairs along the long edges. Press the seams open, then attach the pairs to form a rectangle. Press the seams open.

2 Enlarge the unicorn template at the front of the book so that it measures 9 inches across. Transfer it, in reverse, to the backing paper of the fusible bonding web. Iron it onto the calico, then cut out along the outline. Peel off the backing paper and iron it onto the center of the patchwork. Draw on the features and other details.

3 Using a narrow satin stitch and gold thread, sew around the outside edge of the motif and over the various details of the design.

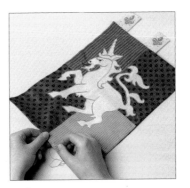

4 Embroider the eye, tongue and nostril by hand or with a machine.

5 Cut three 6-inch lengths of ribbon, matching the design, and remove the wire from the edges. Fold each piece in half and pin, then baste in place on the upper edge of the banner so that the loops are facing downward.

6 With the right sides facing, pin the backing fabric to the banner and sew around the edge leaving a seam allowance of ½ inch. Leave a 4-inch gap at the lower edge for turning. Trim the corners and turn. Press.

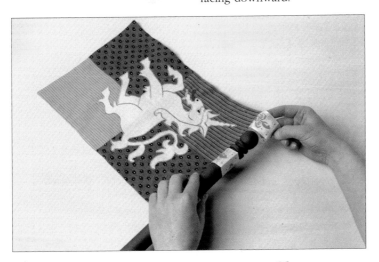

7 Paint the pole and let it dry, then thread the banner onto the pole.

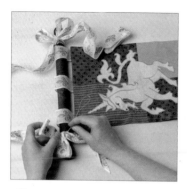

8 Tie each end of the
remaining ribbon onto the
pole in a bow. Secure with a
few stitches and pull the wired
edges of the loops into shape.

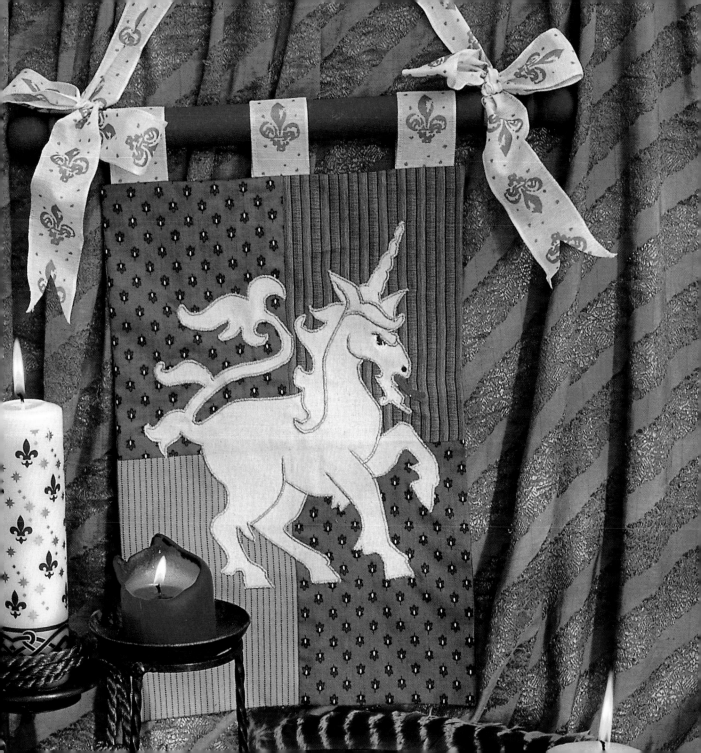

HERALD MIRROR

This festive papier-mâché herald is blowing a fanfare for your reflection – he's swapped his armorial banner for a miniature mirror. Paint his multicolored costume in cheerful, bright shades to suit the mood of the piece.

YOU WILL NEED

MATERIALS
thin cardboard
white glue (diluted)
newspaper
mirror, 2¼ square inches
white acrylic or matte latex
 paint
acrylic paints: red, purple, black,
 white, brown, green, gold,
 rose, blue, ivory gold paint
gloss varnish
½ yard narrow red ribbon
picture hook

EQUIPMENT
tracing paper
pencil
ruler
scissors
paintbrushes

1 Copy the template at the back of the book and cut out of thin cardboard. Using diluted white glue, cover with several layers of newspaper, building up the cheeks, nose, wavy hair and legs to create a relief effect. Let dry.

2 Cut two 2½-inch squares of cardboard and glue the mirror in the center of one. Cut out the center of the second square leaving a ½-inch frame. Cover with newspaper strips. When dry, stick the frame to the mirror and backing, and build up with more layers of newspaper. Pierce two holes in the top of the frame with scissors.

3 Prime the herald and the mirror frame with white acrylic or latex paint. When this is dry, decorate with acrylic and gold paints. When the paint is dry, protect with gloss varnish. With the ribbon, tie the mirror onto the trumpet. To complete, screw the picture hook into the back of the herald's shoulder.

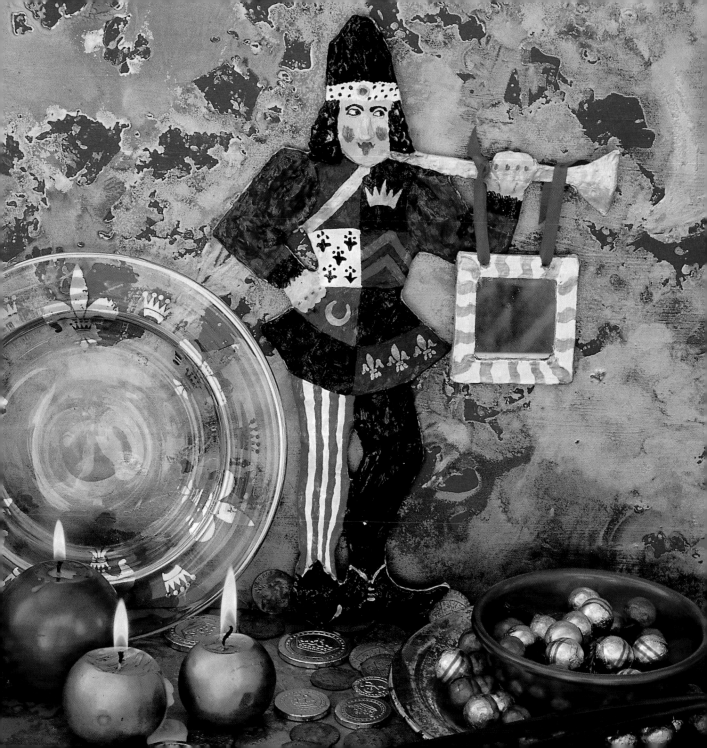

GILDED GRIFFIN BOOKMARK

Look for pictures of old engravings and heraldic devices for this découpage. The clearly defined images will photocopy perfectly and look great once they've been cleverly aged with tea. Try to use cardboard that's stiff but not thick, so that the bookmark won't be too bulky.

1 Using a craft knife and metal ruler, cut a rectangle of cardboard 6 x 2 inches, and cut off the corners diagonally.

2 Paint with acrylic gesso. Mix a red oxide color using red, orange and green acrylics and paint it all over the bookmark. When dry, cover with gold paint, leaving some of the red oxide showing through.

3 Make a very strong solution of tea and paint the photocopies with it to create an aged appearance. Let the copies dry, then cut out.

4 Stick on the cutouts with white glue and varnish with diluted white glue to seal. Glue a length of velvet ribbon to the back of the bookmark.

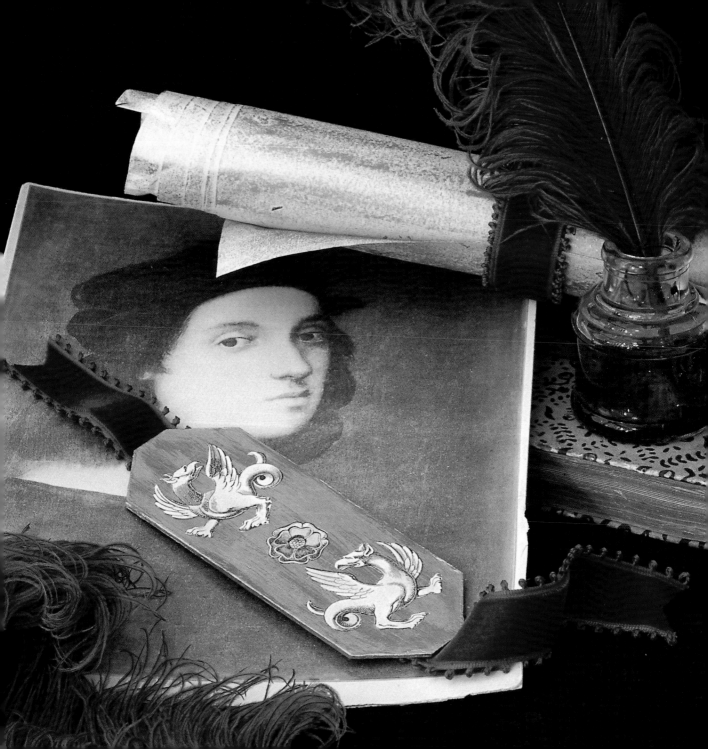

HERALDIC SHIELD PICTURE

This design echoes the armorial panels that you might see hanging in churches. The diamond is called a lozenge in heraldry.

YOU WILL NEED

MATERIALS
self-hardening clay
gold paint
acrylic paints: red, yellow,
 purple, dark green, white,
 black
1⅜ picture frame molding,
 1 yard
medium-density fiberboard,
 9½ square inches
wood glue
blackboard paint
gilt wax
picture hook

EQUIPMENT
acetate sheet
rolling pin
metal ruler
round- and square-ended
 modeling tools
tracing paper
pencil
pin
bamboo skewer
fine-grade sandpaper
paintbrushes
coping saw

1 Roll out the clay on acetate to a thickness of ¼ inch, and trim to a 6½-inch square. Trace the design from the back of the book and lay it on top of the clay tile. Use a pin to prick along the lines and transfer the design. Use a round-ended modeling tool to indent the design around the curves, and a square-ended tool for the straight lines. Use a bamboo skewer to mark dots and eyes. Let the clay harden over several days.

2 Rub down the edges with sandpaper and paint in gold and acrylic paints. Let dry.

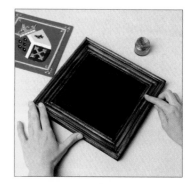

3 Cut the frame molding and miter the corners to fit around the fiberboard; glue in position. Paint the frame with two coats of black paint. When dry, rub some gilt wax over the frame to highlight. Glue the clay tile inside and screw a picture hook in the back.

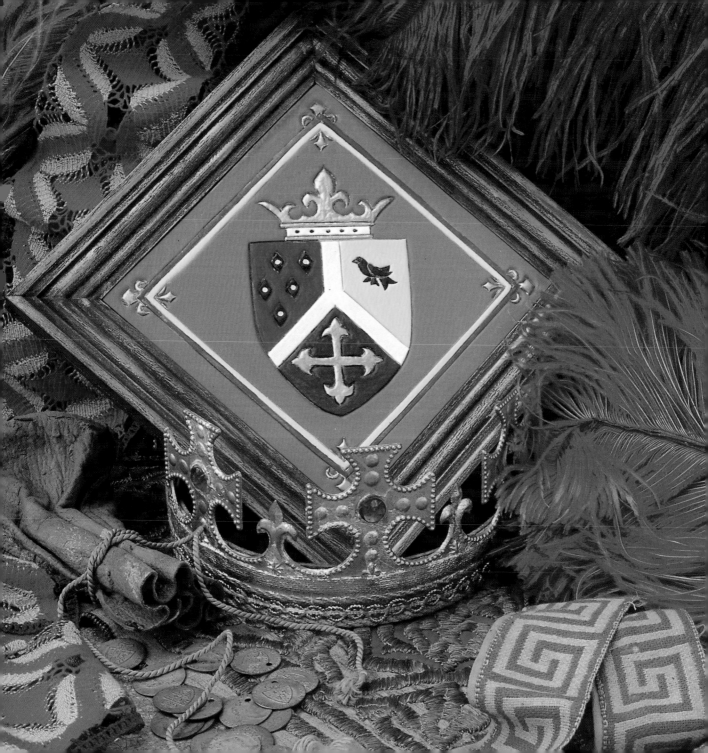

HERALDIC SYMBOLS MOBILE

There are plenty of strong, simple shapes in heraldry, just right for cutting out to hang on this unique 3-D banner. The small motifs on a heraldic shield are called charges. Pick out the raised detailing on each shape in gold to catch the light subtly.

YOU WILL NEED

MATERIALS
stiff cardboard
newspaper
wallpaper paste
acrylic gesso
acrylic paints: cobalt blue,
 yellow, orange, red, purple,
 black
28 earring pins
super glue
gold felt-tip pen
fine thread
½-inch wooden dowel,
 14 inches long
2 large wooden beads
2 brass screws
gold paint
3 red tassels
length of red cord

EQUIPMENT
paper for template
pencil
carbon paper
craft knife
metal ruler
scissors
glue gun
paintbrushes
fine- and coarse-grade
 sandpaper
drill
screwdriver
sewing needle

1 Scale up the template at the back of the book to measure 12 inches across, and transfer the design to the cardboard using carbon paper. Use a craft knife and metal ruler to cut out the main shapes.

2 Cut out the charges with scissors. Tear strips of newspaper and coat them with wallpaper paste. Cover the banner with a layer of papier-mâché, using tiny strips of paper for the small charges.

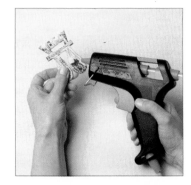

3 Let dry, then apply a second layer of newspaper strips. Once this is dry, create the raised designs on the motifs using a glue gun.

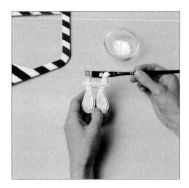 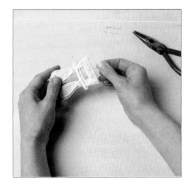 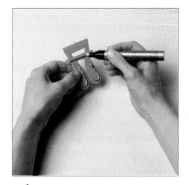

4 Paint all the pieces with two coats of acrylic gesso, sanding lightly between the layers. Mark diagonal stripes on the banner with a pencil and ruler and paint alternate stripes in cobalt blue.

5 Insert an earring pin in the top center of each charge and secure with a few drops of super glue. Attach an earring pin at each corresponding point on the banner in the same way.

6 Paint the charges in different heraldic colors. Highlight the raised design with a gold pen. Once the pieces are dry, assemble the mobile using fine thread. Apply a drop of glue to each knot.

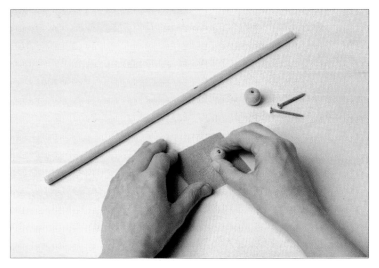

7 Drill a hole in each end of the wooden dowel. Flatten one end of each bead by rubbing with coarse sandpaper, then screw the beads to each end of the dowel. Coat with gesso and paint gold.

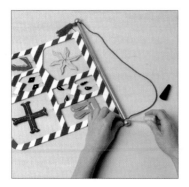

8 Stick three earring pins along the top of the banner and tie to the dowel with fine thread. Sew a tassel to each end of the red cord and slip the tassel loops over the beads. Glue to the dowel. Use an earring pin to attach the third tassel to the bottom of the banner to complete.

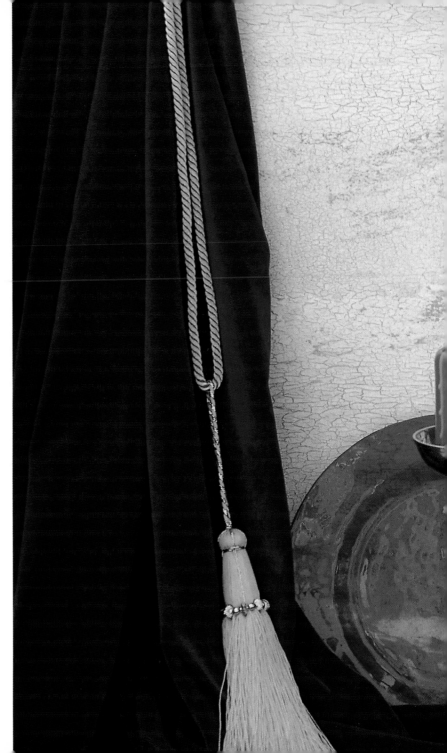

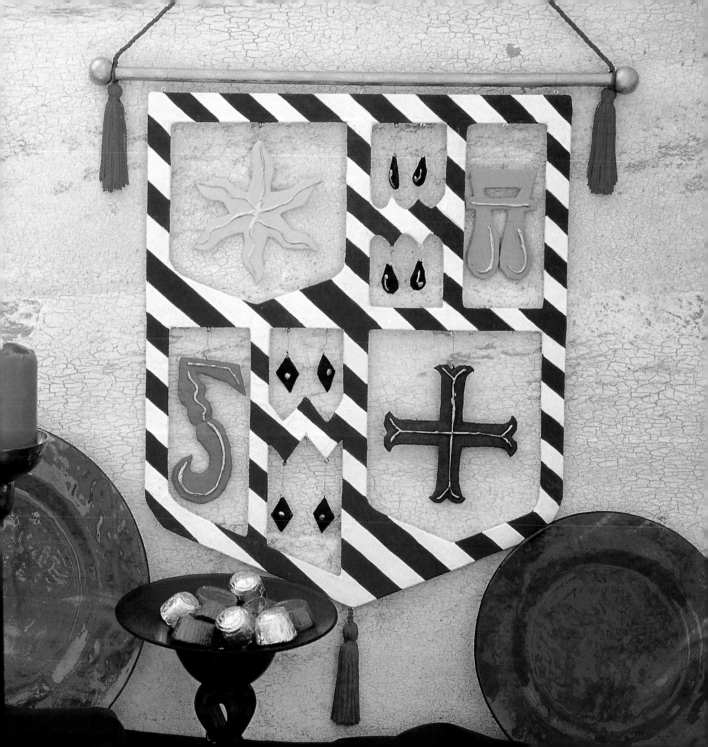

MEDIEVAL CORK TILES

Transform ordinary unsealed cork tiles into medieval terra-cotta using a variety of wood stains. They produce just the right range of muted shades, and you can mix them together to add even more subtlety to your designs. Experiment with the colors on a spare piece of cork, or on the backs of the tiles.

YOU WILL NEED

MATERIALS
unsealed, unstained cork tiles, 12 square inches
wood stains: pine (yellow), red and brown mahogany
permanent black ink
waterproof gold ink (optional)
matte polyurethane varnish

EQUIPMENT
brown crayon
ruler
thin cardboard for template
pencil
scissors
fine and medium paintbrushes
fountain pen and ink

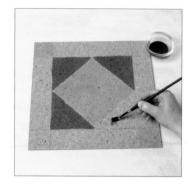

1 Using the template at the back of the book as a guide, mark the geometric pattern on a tile. Use a brown crayon that will merge in with the design. Paint with the various wood stains. They spread on the cork, so don't overload the brush and start in the middle of each area, working outward. A narrow gap between each color looks very effective.

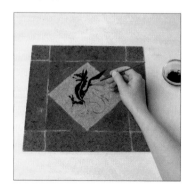

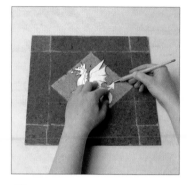

2 Scale up the animal template as required, transfer to thin cardboard and cut it out. Position it in the center of the tile and draw around it with permanent black ink, using a fountain pen.

3 Use a fine brush to fill in the animal design in black. Highlight the design with gold ink, if desired. Finally, seal the tile with several coats of polyurethane varnish.

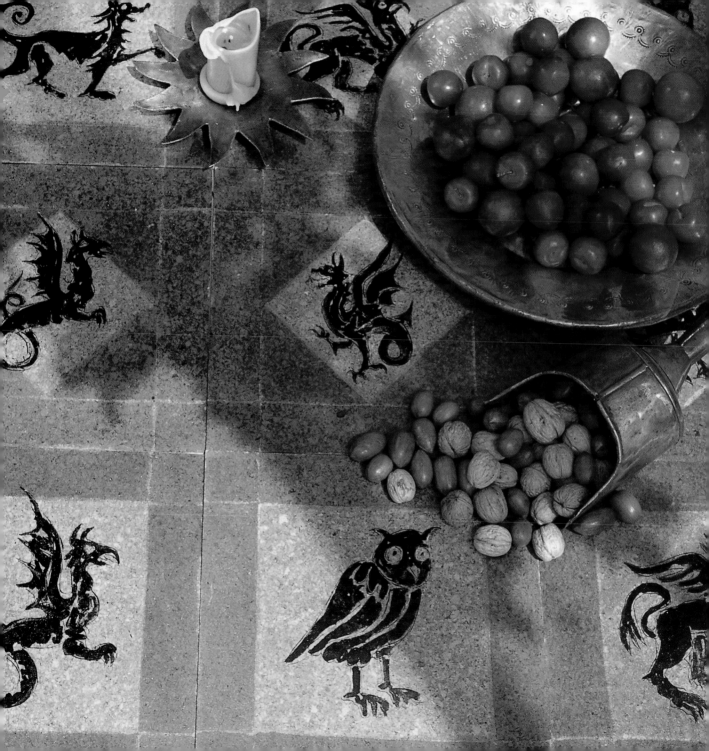

DIAMOND NAPKIN RING

The diamond-shaped lozenge is used by women to display their family coat of arms instead of the more familiar shield shape. This miniature lozenge includes a splendid golden lion; in this position he is heraldically described as a "lion passant gardant or."

YOU WILL NEED

MATERIALS
cardboard tube
thick cardboard
newspaper
wallpaper paste
acrylic gesso
acrylic paints: blue, red, yellow,
 light gold, black, white
gloss acrylic varnish

EQUIPMENT
tracing paper
hard and soft pencils
craft knife
cutting mat
bowl
pen
fine and medium paintbrushes
glue gun or epoxy resin glue

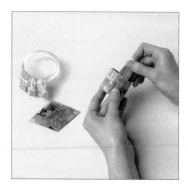

1 Trace the template at the back of the book and cut a diamond shape out of thick cardboard. Cut a 1½-inch section from the cardboard tube. Tear the newspaper into narrow strips and coat with wallpaper paste. Cover the ring, including the edges, with several layers of papier-mâché. Cover the diamond with about ten layers in the same way.

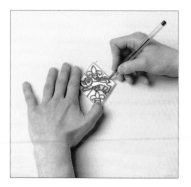

2 When the papier-mâché is dry, prime with three coats of acrylic gesso. Transfer the traced design onto the diamond by rubbing over the back with a soft pencil, then drawing over the outlines.

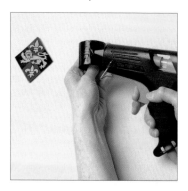

3 Paint the background diamonds in blue and red, and the lion and fleur-de-lis in yellow. Highlight the design in light gold paint and outline the shapes in black. Pick out details in red and white. Paint the ring with two coats of blue. Seal the diamond and ring with acrylic varnish and when dry glue the two parts together.

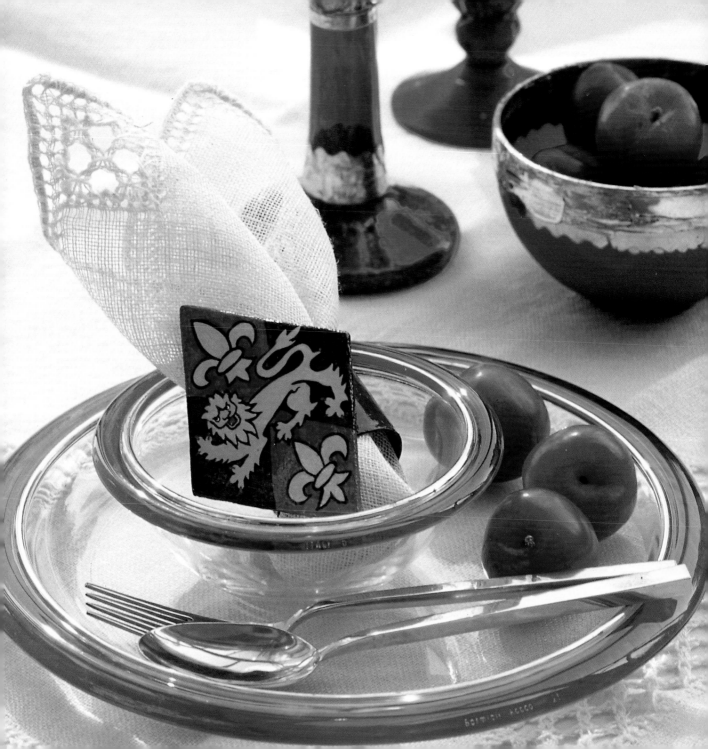

HERALDIC SWAN BOX

The stately swan, with its many regal associations, has long been depicted on coats of arms. The long and graceful neck of the heraldic bird is often adorned with the noble insignia of a coronet. This medieval patterned box is decorated with a dignified white swan standing against an ornate blue background.

YOU WILL NEED

MATERIALS
hexagonal box with lid
acrylic gesso
craft paints: medium blue, dark blue, white, orange, black
gold and silver paint
matte acrylic varnish

EQUIPMENT
fine and medium paintbrushes
thin cardboard or paper for template
pencil
scissors
ruler
coarse sandpaper

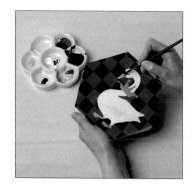

1 Prime the box with two coats of gesso. Enlarge the template at the back of the book so that it fits the box. Transfer to thin cardboard and cut out. Draw around it onto the lid then rule a grid of ¾-inch squares all over the background. Paint these alternately in medium and dark blue. Paint the swan white and add the details on the head and wing in black. Paint the coronet, feet and beak in a rich orange and add gold to the coronet.

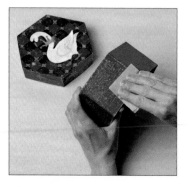

2 Paint the lid edges and box sides in two shades of blue. When dry, rub very lightly over the whole box with sandpaper to give a distressed look.

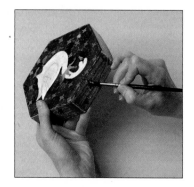

3 Paint silver diamonds over the corners of the background squares and add a tiny gold dot at each corner. Paint gold stars around the edges of the lid. Seal the box with several coats of varnish.

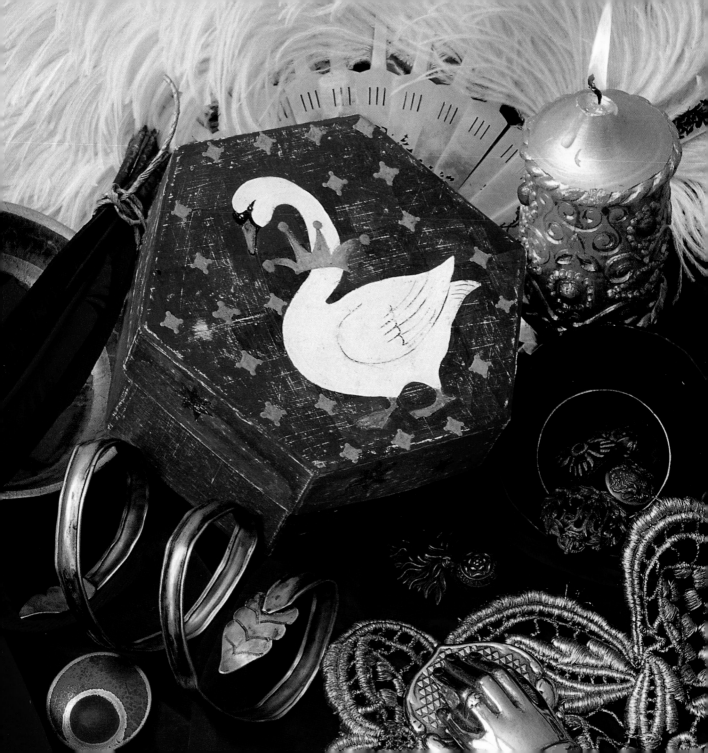

TUDOR ROSE EMBROIDERED BUTTON

Use these pretty buttons to add sparkle to a plain jacket or dress. They are based on the theme of the Tudor Rose, a famous heraldic union of the red rose of Lancaster and the white rose of York. The motif can frequently be seen embroidered on costumes in portraits of the Tudor monarchs.

You Will Need

MATERIALS
water-soluble fabric
machine embroidery floss:
 green, red and white
fine metallic thread
a few small pearl beads
¾-inch cover buttons,
 white glue
small piece of metallic fabric
small piece of sheer organza

EQUIPMENT
embroidery hoop
felt-tipped pen
embroidery needle
sewing machine
scissors
paintbrush

1 Stretch the water-soluble fabric onto the embroidery hoop. Trace the design from the back of the book onto the fabric using a felt-tipped pen. Embroider the leaf detail in green by hand or machine, using straight stitch and sewing back and forth to link the stitches. Cut off the trailing green threads and hand- or machine-embroider in red or white over the flower, making sure that you interlock the stitches. To make the mesh, thread the machine with metallic thread and sew straight rows first one way, then the other, to make a net. Remove the embroidery from the hoop.

2 Cut around the flowers and mesh and sew them together, adding a few beads, before you dissolve the water soluble fabric.

3 Follow the manufacturer's instructions for covering the buttons. Cut circles of metallic and sheer fabrics and dab a little glue in the center of each button before covering with the layers of fabric.

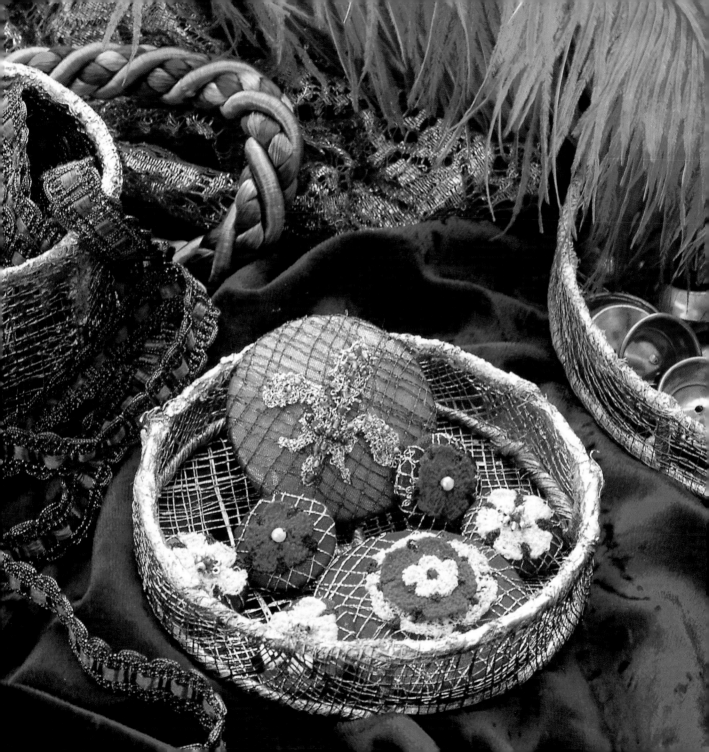

PAINTED WHISKEY GLASS

The fleur-de-lis was the heraldic emblem of the kings of France from the 12th century on. You can use this ancient motif to make a plain glass special. Paint each large motif in a different combination of colors, matching them with the small motifs on the opposite side.

YOU WILL NEED

MATERIALS
whiskey glass
black cerne relief outliner
glass paints: red, blue, yellow

EQUIPMENT
rubbing alcohol
paper towels
tracing paper
fine black pen
tape
paintbrushes

1 Wash the glass in warm water and detergent and dry thoroughly. Wipe over the surface with a cloth and alcohol to remove any traces of grease. Divide the base of the glass into three equal sections and mark with cerne relief.

2 Trace the large fleur-de-lis motif from the back of the book and tape it inside the glass. Draw the design carefully with the black outliner. It is easiest to do this in sections, letting each section dry for at least 12 hours before starting the next. Outline the small motifs in the same way.

3 Color the first large motif, using different colors for each section, and let dry overnight before turning the glass for the next motif. Paint each small fleur-de-lis in colors matching the motif on the opposite side of the glass. When you have finished, scrape off the reference marks on the base and let the paint dry thoroughly before washing.

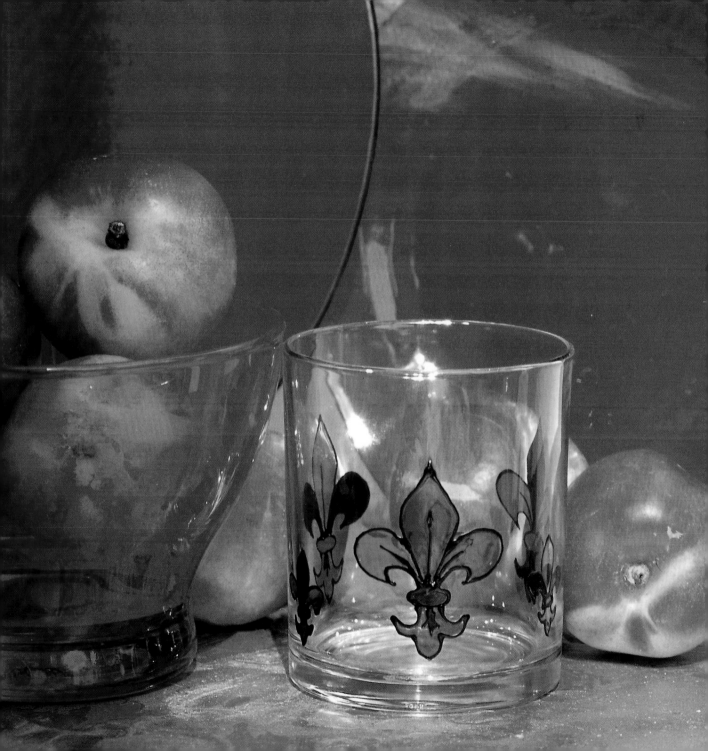

CORONET PICTURE FRAME

Crowns have symbolized royalty from very ancient times, and naturally became an important symbol in the repertoire of heraldry.

YOU WILL NEED

MATERIALS
*¾-inch medium-density
 fiberboard, 7 x 9 inches
polyester batting,
 9 x 14 inches
crimson velvet, 18 square
 inches
20 inches gold braid,
 ¾ inch wide
double-sided tape
20 inches gold cord
selection of large sequins or
 filigree buttons
tin sheet or silver cardboard,
 14 x 7 inches
diamante or glass gems
scrap paper
white velvet, 2 x 6 inches
heavy cardboard, 7 x 10 inches*

EQUIPMENT
*ruler
pencil
jigsaw tin snips
scissors glue gun
staple gun
thin cardboard, for template*

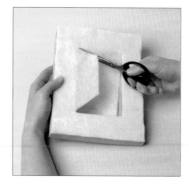

1 Cut a 3½ x 5½-inch rectangle from the center of the fiberboard to make a frame 1¾ inches deep. Cover the front with two layers of polyester batting and snip out the area in the center.

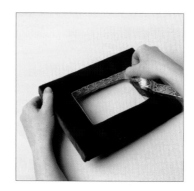

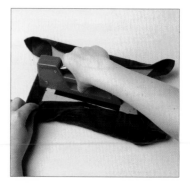

2 Cover the frame with an 11 x 14-inch rectangle of crimson velvet, attaching securely at the back with a staple gun. Make a slit in the center and snip into the inner corners. Pull the inner edges of the velvet to the back of the frame and staple.

3 Attach double-sided tape to the back of the gold braid. Remove the backing paper and stick around the inside edge of the frame to cover the raw edges. Stick a length of gold cord around the lower edge of the braid.

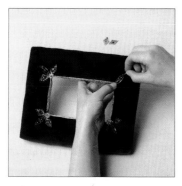

4 Sew sequins or buttons to the four inside corners of the frame.

5 Enlarge the coronet template at the back of the book so that it measures 6 inches across, and cut it out of thin cardboard. Draw around it on tin or silver cardboard and cut out. Bend the side tabs inward and curve the coronet gently. Decorate with diamante or glass gems stuck on with a glue gun.

6 Cut an oval shape from the remaining crimson velvet and sew a gathering thread around the edge. Crumple a sheet of paper and place in the center, then draw up the thread. Attach inside the coronet with a glue gun.

7 Trim the top of the heavy cardboard to fit the frame, leaving a wide tab to support the coronet. Tape the picture to be framed to the back of the opening, then staple the board to the back of the frame.

8 Use the glue gun to attach the coronet to the frame and board. Conceal the seam by turning in the raw edges of the white velvet to make a narrow band and gluing it around the base of the coronet.

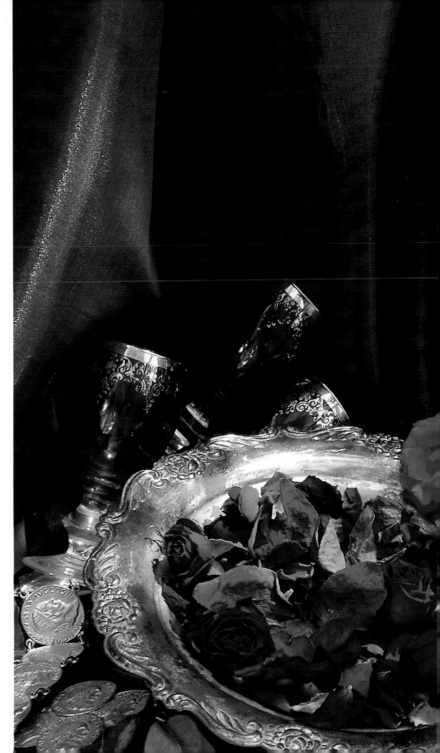

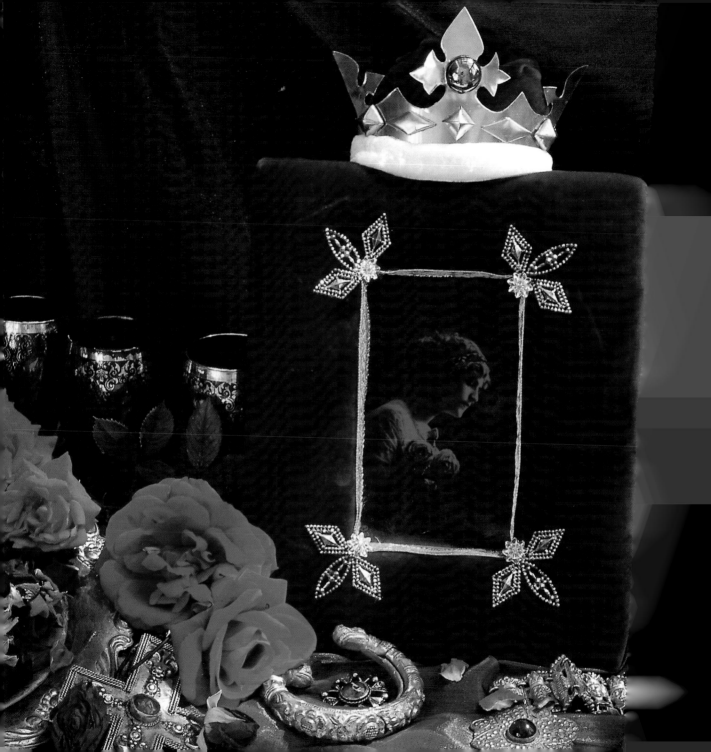

MOSAIC SHIELD WALL PLAQUE

This plaque uses simple square tiles to build up the design. By carefully mixing light and dark shades, you can give the impression of the curved edge of the shield without having to cut the glass pieces.

YOU WILL NEED

MATERIALS
¼-inch medium density
 fiberboard, 9 x 12 inches
1-inch glass mosaic squares
white glue
white grouting
2 screw eyes
8 inches picture wire

EQUIPMENT
pencil
ruler
tracing paper
paintbrush
damp cloth
soft, dry cloth

1 Draw a line 1 inch in from each edge of the fiberboard, then draw a line down the center of the board. Draw a horizontal line 4½ inches from the top, then mark in a gentle curve in each lower quarter. Trace the shield shape onto tracing paper and use this as a base for working out the design. Take time to find a satisfying arrangement of colors.

2 Paint a thick layer of glue in the top quarter of the shield and stick on your chosen tiles. Surround these with a single row of white around the outside edge, and a darker color along the center lines. Repeat with the remaining quarters.

3 Let sit overnight for the glue to harden, then fill in the spaces between the tiles with grouting. Wipe off the surplus with a damp cloth and, when dry, polish with a soft cloth. Put the screw eyes into the back and attach the wire for hanging.

ARMORIAL WASTE-PAPER BASKET

Complete a baronial look in your sitting-room or study with an elegant waste-paper basket. Containers ready for painting can be bought at specialty craft stores, or you could use any appropriate container.

YOU WILL NEED

MATERIALS
¼-inch foamcore or
 corrugated cardboard
waste-paper basket
glue stick
cotton piping cord
acrylic gesso
thin cardboard
acrylic paints: red, yellow and
 dark green
shoe polish: brown, black and
 neutral
gold size
Dutch gold leaf
polyurethane varnish

EQUIPMENT
paper for templates
pencil
scissors
craft knife
cutting mat
glue gun
fine and thick paintbrushes
paper towels

1 Scale up the templates at the back of the book for the shield and cross motifs and cut out of paper. Draw the shield motif four times on the foamcore and cut out with a craft knife. Stick the shields on to the sides of the basket with the glue stick. Cut lengths of cotton cord to go around the shields and tie at the bottom in a bow. Stick them on with a glue gun.

Paint the whole piece, inside and out, with two coats of acrylic gesso. Paint a piece of thin cardboard with gesso and, when dry, draw around the cross template four times on this. Mix red, yellow and green acrylic paint to resemble red oxide primer and paint the shields and the top edge of the basket.

2 Using a large brush in a random sweeping motion apply patches of brown and black shoe polish, each mixed with neutral to tone them down, over the white gesso, including the string and the cross motifs. Wipe the polish off with paper towels as you go, to build up the desired antiqued effect.

Cut out the crosses. Paint a thin layer of gold size on the red oxide areas and when it is nearly dry gently apply the gold leaf and rub it down through the backing paper with your thumbnail. Rub harder in some areas to reveal the red oxide beneath.

Put a spot of gold leaf in the center of each cross motif. Stick a cross to the center of each shield with the glue stick. Coat inside and out with polyurethane varnish.

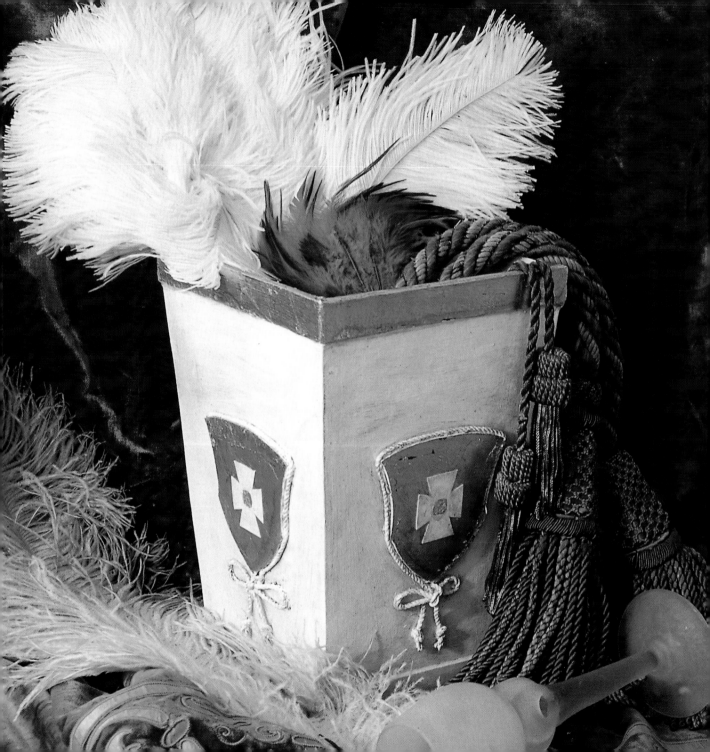

FLEUR-DE-LIS TIEBACK

Make this chic, tieback to add restrained elegance to a plain or striped curtain. The fleur-de-lis, or heraldic lily, is so stylized that it hardly resembles a lily at all – and may in fact be based on the shape of an iris or even a spearhead.

YOU WILL NEED

MATERIALS
white cotton poplin, 8 x 36 inches
navy cotton poplin, 12 x 36 inches
navy and white striped cotton poplin, 20 x 36 inches
polyester batting
fusible bonding web
matching sewing thread
two white "D" rings

EQUIPMENT
tracing paper
pencil
pins
scissors
thin cardboard or paper for template
iron
basting thread
sewing needle
sewing machine

1 Scale up the tieback template to the width required for your curtain and trace, marking the top and bottom of each motif. Cut out the shape in each of the fabrics and the batting. Mark the positions of the motifs on the white fabric.

2 Trace the fleur-de-lis motif and cut out a cardboard template. Draw around it seven times on the backing paper of the bonding web and iron onto the remaining navy fabric. Cut out the shapes carefully.

3 Iron the motifs onto the white fabric. Layer the batting between the striped and navy fabrics, lay the white fabric on top and baste. Quilt around the motifs. Cut two 2¼-inch bias strips from the striped fabric. Pin one piece along the top edge and stitch, leaving a ⅝ inch allowance. Fold the binding to the back, turn in the raw edge, pin and hem. Stitch the second strip along the bottom edge. Loop each end of the binding through a "D" ring, turn in the raw edge neatly and stitch.

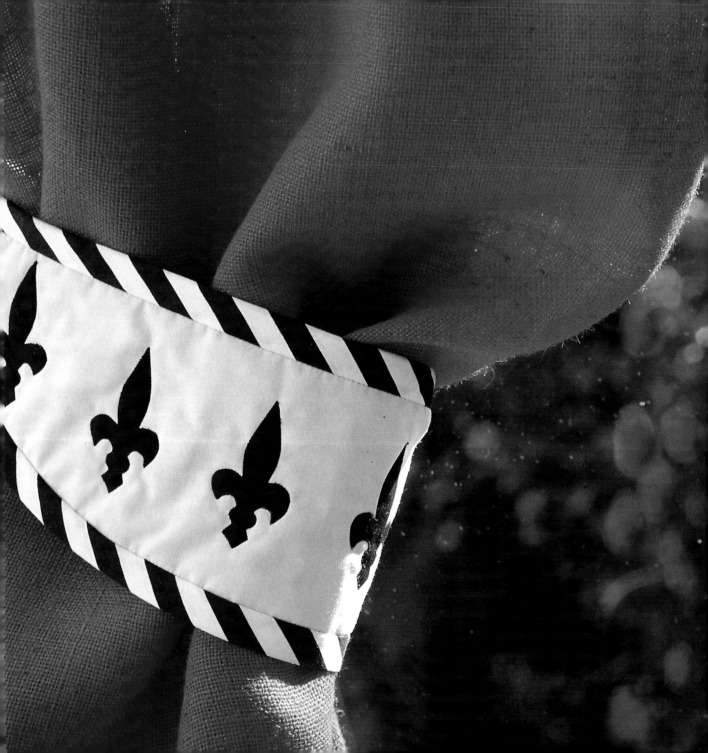

HERALDIC PLACEMAT

Medieval retainers used to wear circular badges with a distinctive family motif on their clothes to identify them with their feudal overlord; such emblems were much simpler designs than armorial bearings and were often animals or flowers. This running stag makes a spirited design for a set of placemats.

You Will Need

MATERIALS
vinyl-coated cotton fabric: plain blue, plain red and co-ordinating print
white glue
muslin or felt for backing
quilting thread

EQUIPMENT
compass
pencil
scissors
paintbrush
thin cardboard or paper for template
sheet of plastic
sewing machine with leather needle

1 Decide on the diameter of your mat and draw and cut out a rim of plain blue fabric. Use white glue to stick this onto the background print fabric, to secure it while you sew.

2 Scale up a heraldic beast motif at the back of the book and transfer it to thin cardboard. Cut it out and draw around it on the reverse of the red fabric. Cut out.

3 Glue the heraldic beast in the center of the mat, and glue a piece of muslin or felt to the back. Cover with a sheet of plastic and leave under a weight until it is dry.

4 Using quilting thread, machine-stitch around the edges of the motif and in rows around the border. Use a long, straight stitch. Trim the edge of the mat and wipe off any glue.

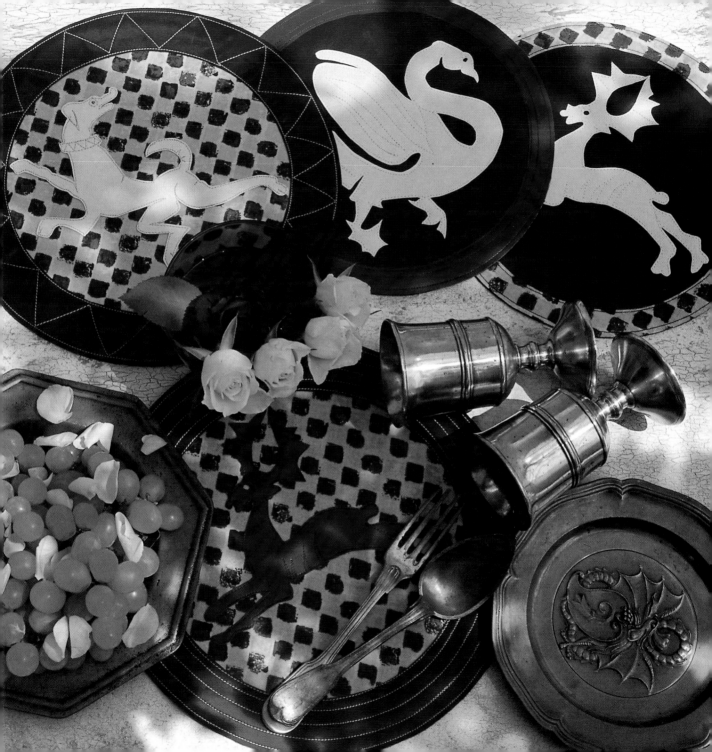

TEMPLATES

To enlarge the templates to the correct size, use either a grid system or a photocopier. For the grid system, trace the template and draw a grid of evenly-spaced squares over your tracing. To scale up, draw a larger grid on another piece of paper. Copy the outline onto the second grid by taking each square individually and drawing the relevant part of the outline in the larger square. Finally, draw over the lines to make sure they are continuous.

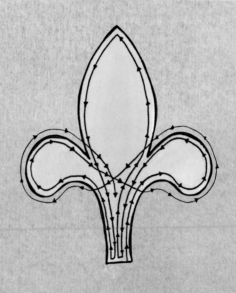

Fleur-de Lis Velvet Shoe Bag, p. 12

Coronet Picture Frame, p. 48

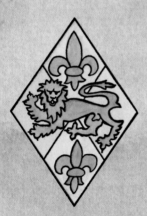

Diamond Napkin Ring, p. 40

Tudor Rose Embroidered Button, p. 44

Armorial Waste-paper Basket, p. 54

English Lion Cushion, p. 14

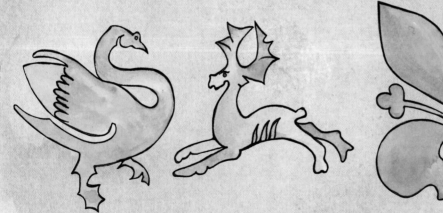

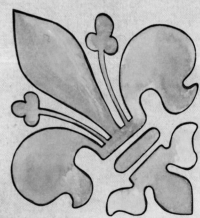

Heraldic Placemat, p. 58

Fleur-de-lis Terra-cotta Tiles, p. 22

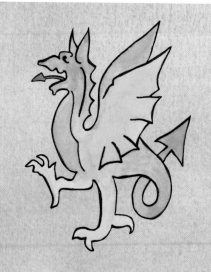

Medieval Cork Tiles, p. 38

Painted Whiskey Glass, p. 46

Herald Mirror, p. 28

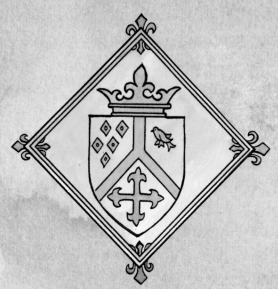

Heraldic Shield Picture, p. 32

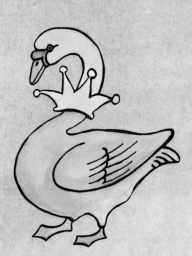

Heraldic Swan Box, p. 42

Fleur-de-lis Box, p. 16

Fleur-de-lis Tieback, p. 56

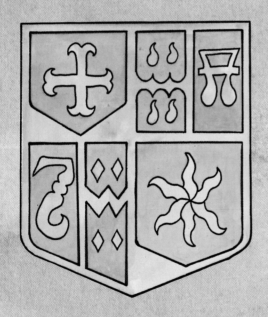

Heraldic Symbols Mobile, p. 34

Unicorn Pennant, p. 24

ACKNOWLEDGMENTS

The author and publishers would like to thank the following people for designing the projects in this book:

Penny Boylan

Fleur-de-lis Velvet Shoe Bag, p. 12;
Gilded Griffin Bookmark, p. 30;
Armorial Waste-paper Basket,
p. 54

Louise Brownlow

Medieval Cork Tiles, p. 38;
Tudor Rose Embroidered Button,
p. 44;
Heraldic Placemat, p. 58

Sophie Embleton

Herald Mirror, p. 28

Lucinda Ganderton

Fleur-de-lis Terra-cotta Tiles, p. 22;
Unicorn Pennant, p. 24;
Diamond Napkin Ring, p. 40;
Heraldic Swan Box, p. 42;
Coronet Picture Frame, p. 48;
Mosaic Shield Wall Plaque, p. 52

Emma Petitt

Heraldic Candle Jar, p. 20

Isabel Stanley

English Lion Cushion, p. 14

Dorothy Wood

Fleur-de-lis Box, p. 16;
Heraldic Shield Picture, p. 32;
Heraldic Symbols Mobile, p. 34;
Painted Whiskey Glass, p. 46;
Fleur-de-lis Tieback, p. 56

Picture Credits
The publishers would like to thank AKG Photo, London for the
following photographs: p. 8 Portrait of Adolf von Nassau by Heinrich
Karl Anton Mucke, p. 9 (both) book illustrations from *Grosse*
Heidelberger Liederhandschrift, p. 10 (left) Sculpture of Charles IV of
Luxembourg by Peter Parler c1379, p. 10 (right) The coat of arms of
Duke Achilles Friedrich, glass painting 1624, p. 11 (left) Charles the Bold
of Burgundy and his wife Isabella, anonymous painting of a Flanders
master of the 15th century, p. 11 (right) inscription and coat of arms of
the Schmidburg and Pistoris families linked by garlands of plants from
the Nikolai Church in Leipsig.